RESIST!
A VISUAL HISTORY OF PROTEST

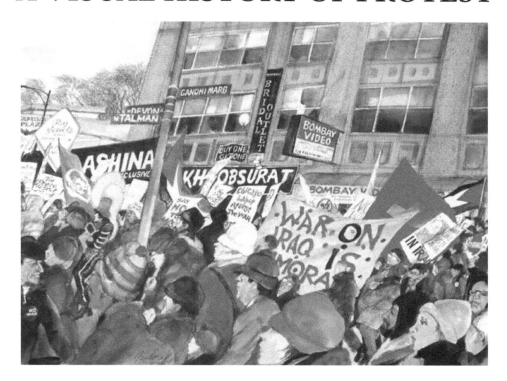

MARGOT McMAHON

AQUARIUS PRESS
Detroit, Michigan

RESIST! A VISUAL HISTORY OF PROTEST

ISBN 978-0-9846212-9-3
LCCN 2022949421

Aquarius Press LLC
www.AquariusPress.net

Printed in the United States of America

Contents

INTRODUCTION
Gloria Groom and Joseph Berton

All artists observe, some of them document what they see, and a few record history.
Franklin McMahon was one of these gifted few that was there for the history.

By the mid-1800's, newspapers were supplementing their written stories with illustrations. For current events, the papers would send their own correspondents into the field to file their reports often supplemented by sketches drawn by an "eyewitness artist" and translated into wood engravings onto the page. Photography would also have an important role as an eyewitness tool. The Crimean War was documented by Roger Fenton and others. The limitation of the medium at the time required the subject to hold the pose. Though perfect for capturing still subjects like important personalities and the arranged camp scenes of soldiers, it was the job of the artist to capture the energy of a cavalry charge or the defense of a redoubt. This became even more obvious during the Civil War. Matthew Brady, his assistants and other talented photographers would document leading men and women of the day and would also head to the battlefields, usually after the shooting stopped. Some of these images help form our own understanding of that war, a war that is visualized in black and white. We see Lincoln and his generals, the dead being gathered for burial, and bodies laying where they fell at the Round Top at Gettysburg. Though we think the photographer is documenting what he sees, we learn that the bodies of the dead have been arranged to help a composition. A young Winslow Homer was a witness to this war and his images were used to complement the written word. Through Homer and his vision, we see the lone sharpshooter in the tree, the pleasantness of a camp scene, the routine of soldiers playing games, and the look of freedom in a slave's eyes. Yes, the artist is witness, but with some editorial freedom, and even manipulation, of what is seen. It is a view of history seen through the artist's eyes.

Into the 20th century, with photography, and eventually film, playing more of a role in documenting life and events, it is interesting to note that major institutions still relied on artists to capture the same significant occurrences. During both WWI and WWII, the governments of the major warring nations appointed official "war artists" to cover them. The U.S. armed forces employed artists in Vietnam and continue to do so through the conflicts of this century, realizing the viewpoint of the creative artist as witness, special and unique.

Franklin McMahon was an eyewitness artist. He would be on the scene, documenting what was happening, quickly sketching, taking notes, and often later, flushing out these drawing into larger, more detailed works. The viewer benefits from Franklin's skill as a documentarian, using his pencil to capture

emotions, his compositional ability to frame and tighten a scene, and an acuity uniquely his, to combine reactions that might have happened seconds apart. He is able to manipulate the scene visually in a way that a photographer or a filmmaker would not be able to do, giving us an image that reads more "real" than the hard evidence of a photograph of the same event.

One of McMahon's most distinctive gifts is his use of line. With simplicity, he is able to capture the personality of his subjects. Viewing his sketches of Reagan, Bush, Clinton, Obama, we see in his sketches, captured in minimal use of line, the very essence of the people we know. In the pencil portrait of a young Obama (p. 41), McMahon portrays the expressive speaker's use of his hands while talking, with that familiar tilt of his head. In the Obama-Clinton sketch (p. 42) he nails the confidence of a young Obama, being witnessed by an admiring Hillary Clinton. And with line, and washes of color, McMahon portrays Reagan with a cowboy hat being placed on his head, in the perfect "ah shucks" moment, a man of the people, in sharp focus in the center of the composition, surrounded by his people, drawn with a softer line and blended, overlapping veils of watercolor (p. 36). That combination of energized line and judicious use of color works brilliantly in his portrait of the bound and gagged Bobby Seale (p. 31). As one of the courtroom artists, it was Franklin's duty to report on the trial of the Chicago Seven. One of its momentous days came when the highly agitated and emotional Seale was ordered by Judge Hoffman, to be bound and gagged, to prevent further outbursts in his court. McMahon, an eyewitness courtroom artist to the trial, drawing from his own courtroom chair, captures vividly, with line and added color, the restrained Seale. On the right side of the composition, with confident gesture drawing of line, are his attorneys. The added color and detail to Seale keeps us focused on him. It seems obvious the filmmakers of the recent *The Chicago Seven*, made use of Franklin's many sketches because of their documentary importance at a trial where cameras were not allowed. And in perhaps a movie tribute, Franklin is portrayed at the end of this trial, sketchbook in hand.

McMahon could also use line in a more descriptive and detailed way, with a keen sense of perspective and seemingly near-obsessive interest in depicting nearly every brick or stone. And somehow it works. This busyness is needed for the scene that shows the growing leisure time available to the middle class and the growth of suburbia (p. 27). By the sixties, many Americans were able to enjoy their time off and spend time watching television. Here we see antennas on every roof, with a man quietly enjoying some moments on the back porch, and laundry drying nearby. McMahon documents a scene played out on many Sundays in cities across the country. Now contrast this with another everyday scene, one of decaying buildings of the inner city with antennas, with less wires connecting to the outside world.

McMahon's talent as an eyewitness artist also captured events that had a cast of hundreds, if not thousands. From conventions to victory parades, protest marches to symphony concerts, McMahon was

there recording what he saw. He would make quick sketches on site, working out compositions, picking out what he would highlight or focus on when he got back to the hotel room or studio, working all of that up to much larger, more finished watercolors and paintings. McMahon went to most of the conventions: Republican and Democrat. For those of us who have watched these conventions on TV, and have own memories of them, we look at McMahon's work, and sense a familiarity, but now we see the scene through his eyes and through his viewpoint. For Jimmy Carter's nomination, we are in the rafters, the cheap seats, while Carter is nominated to be the candidate of his party, and the balloons start to drop (p. 34). On the left side, in what is perhaps the television control booth, we see a beaming Carter, ready to accept the nomination, and to the right, are hundreds of balloons and Carter banners. McMahon is able to capture the energy, and it seems, even the noise of the event, refreshing our own memories of it.

Similar elation and hope are also expressed by McMahon's painting of Senator Barack Obama giving the keynote speech at the 2004 Democratic National Convention (p. 42). In this highly anticipated speech, Obama delivered a stirring address. McMahon, from his viewpoint, puts Obama at the center of the composition. All lines focus on the small figure at the heart of the painting, on a swath of blue carpeting. The perspectival lines made up of figures and political signs guide our eyes to the middle, and there, in the top left corner, McMahon gives us the large stadium television monitor showing Obama in close detail, in mid-speech.

Patently more subdued is McMahon's depiction of Nixon, speaking at his convention in Miami Beach for his re-election. McMahon himself is on the floor, close to Nixon, who we see speaking at the podium, with wife Pat seated nearby. In the lower center of the painting, a policeman, with the recognizable checkered hatband watches us, and in the lower right corner, McMahon draws with a certain irony, a convention sign that reads "Happiness is Re-electing our President," complete with a smiley face.

Throughout his life, resistance played a role in his art. This book is titled *Resist!: A Visual History of Protest*. McMahon knew how to resist. He had to, sometimes quietly and sometimes loudly, as a prisoner of war. And in post-WWII America, resistance was a daily occurrence in response to current events. It was the death of Emmett Till, the resulting outrage, and the trial of his accused killers that was part of his time (p. 18). Franklin grasped the importance of his assignment for *Life*, which he completed under an extreme deadline. The reward was knowing his documentary drawings would reach millions. From then on McMahon was as much artist as artist-journalist for justice. He witnessed the 1968 Chicago protest marchers and the trial of the Chicago Seven, the anti-war marchers and the rise of the Women's Movement. In his drawings, we see the slums, the quiet walk of the poor-trodden looking and hoping for change. We see the housing projects. We see angry citizens demanding change.

Franklin knew the horror of war, the human cost of it. He was a participant on a bomb crew, that

brought death and destruction to the people below. Some of the remembrance of the horror of war are seen in his evocative drawings made during visits to the memorials at Auschwitz and Hiroshima.

His faith was important too, and he was a witness to the divisive changes taking place in the Catholic Church, documenting the individual protests of brave priests and nuns, helping to lead to the reforms of the Ecumenical Council.

It is rewarding to study Franklin's art, what he saw and what we know in the context of history but Margot, his daughter, brings a much closer perspective, what it was like to have had a front row seat around the family's "bowling alley table" with a father who spoke openly of art and its making, and as a complement to the political and cultural events of his time. In *Resist!*, Margot vividly recollects these stories and it is no wonder that the McMahon family continues to be creatively engaged with our times.

Franklin always remained sympathetic to these causes and the right of individuals and groups to protest, to resist. Over his sixty-year career his art serves as a witness to those times. He joins the long legacy of the artist as documentarian. He is an eyewitness we can trust, and his images will continue to endure to be our guide.

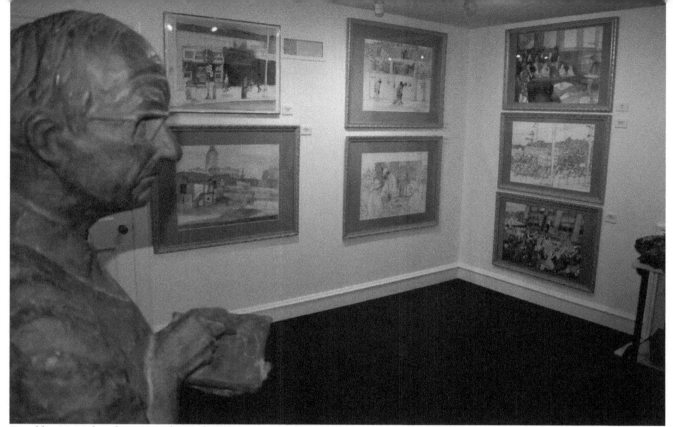

Franklin McMahon bronze sculpture by Margot—RESIST! exhibition at the Lake Forest Lake Bluff History Center

Preface

Their daughter compiled stories too harrowing for them to tell of Franklin (Mac) and Irene McMahon's Greatest Generation life. Their tidbits of tales scattered through decades were drafted into stories, checked with Mac and revised. Stories Irene mentioned she published in travel articles and columns. Margot McMahon curated Mac's artwork to express their symbolic experiences. Chapters explore the life of Mac, an artist, who exposed raw injustices to nudge society in the right direction with humor and expressive lines of graphite on paper and vivid watercolor. Artist reporter, Mac humorously exposed societal oppression, redlining, injustices, and rebellion in lyrically graphite on paper and paintings. Irene interviewed on location and wrote journalistic articles to summarize their world-changing experiences. Margot gathered their tidbits of tales, expressions of their art and written articles to summarize symbolically a story per decade.

In 2018, Margot curated an exhibition of her father, Franklin's, artwork, to celebrate the Fiftieth Anniversary of the Fair Housing Act for the Oak Park Art League by invitation of Executive Director

Julie Carpenter. She exhibited *RESIST! A Visual History of Protest* as a chronicle of five decades of protests drawn and painted by Franklin McMahon from 1945 through 2008. Combined with his Chicago Conspiracy Trial artwork, fifty paintings circled the gallery of the Oak Park Art League to summon memories of 1960s, 70s, 80s, 90s and into the next millennium that led to social justice change. Gallery visitors watched Margot's son, Brendan Burke's Illinois State-awarded *Conspiracy Trial* video including his grandfather's artwork.

In 2018, *RESIST! A Visual History of Protest* exhibition celebrated the new Lake Forest-Lake Bluff History Center. Margot and her family read the chapter "1968 Happened" in a staged dinner table conversation inspired by her cousin, Kathleen Burgess's short story about stewarding military to Viet Nam. They conjured laughter and tears from this lifetime shared with friends and neighbors through January, 2019. Northwestern University's Pritzker Law Library exhibited Mac's Chicago Conspiracy Trial art with digital images from the Chicago History Museum collection from 2019 through 2021. Oak Park's History Museum still exhibits Mac's drawing of a fair housing protest on Marion Street next to Mac Robinet's banner that Mac McMahon drew with graphite on paper. Mac Robinet stored his protest banner in his garage for fifty years, during which time his daughter taught Margot's third grade daughter. In 2022, the Ukrainian Institute of Modern Art exhibited a comprehensive *Resist!* in the reawakening period after shelter-in-place, President Biden's Inflation Reduction Act passed while Ukraine is fighting for democracy.

Mac's recognition of oppression began during his Army Air Corps experiences in three WWII POW Camps. After interrogations, Mac was a prisoner in Stalag Luft III of *The Great Escape*, Stalag XIII D of *Hogan's Heroes*, and Wehrmacht VII A, liberated by Patton's Third Army. *RESIST!* exhibits moments that Margot did not witness. In the 1960s, she arrived home from school but Mac, or Dad, was often on-location capturing current events. He returned for dinner with his visual stories to show at the dinner table. Each had a dash of humor. Mac's artwork triggered her curiosity and offered Margot the clues to uncover his story, his purpose, and his passion. When his seat was empty again at the end of the dining table, she knew he was chronicling his time somewhere.

"Chronologically, Dad's first place of protest was a POW camp in 1945 Germany," said Margot. "When he told my middle-school-aged son his WWII experience, I heard Dad's story for the first time. Dad drew the Auschwitz gates in 1979 when Pope John Paul II said Mass at the concentration camp. The meticulousness of his graphite lines on paper image triggered my emotions of what Dad might have experienced being marched into the Stalag III gate as a twenty-four-year-old in Sagan, Germany's coldest winter in history. Here's Mac's story."

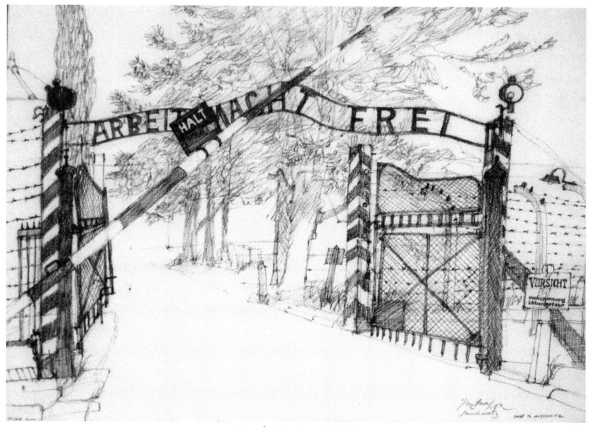

Auschwitz Gate (1979)

1945—Worlds Within Worlds, Stalag Luft III

After taking his ID card and being fingerprinted, twenty-four-year-old Mac was put into a tiny six-feet by six-feet cement cell with fleas for company. The Austwerteselle method of interrogations was generally amiable yet incorporated hunger, temperature fluctuations, and solitary confinement. The air was cave-like and closed in—it had a kind of flinty odor and was very shadowy with a darkness that could enclose a man. Alone, in silence, he sat for days at a time. Each man was wearing a blue denim shirt with a large white "P" on the back —"P" was the target. Mac paced three feet with his one shoeless foot colder than the other.

Guards clicked the heat on and forgot it was on. The cells got so, so hot. Mac was plagued with thirst. He stomped about while he grappled with the immoral, senseless acts of war. Was torturing prisoners to obtain information more reprehensible than dropping bombs? How was he going to get a boot? He

hadn't felt his boot flying off during the free fall before opening his parachute. Mostly, he was thinking about the landing—and if his chute was going to open. Parachuting through flak-filled, thirty-below-zero temperatures into enemy Germany helped him be grateful for too much heat in the cell. Guards walked along and turned off the heat and forgot it was turned off. The cells got very, very cold. He shivered with aching thirst. His unshod foot was nearly frostbitten. Mac tried to think about the scorching training in Arkansas and Texas during mid-day heat. Army training helped when his plane pulled out of a spiraling dive. By procedure, he was the first to jump into flak-filled skies, trying to keep his wits about him. *Our Father who art in Heaven, hallowed be thy name...*

Mac knew his crew was being interrogated also. They all worried about the waist gunner, who talked too much. Churning about him, the great folding cloud of thoughts closed in. He listed his belongings: one boot, the map, a blanket, an empty canteen, his coat, his pants, his prayers. Repeatedly: William F. McMahon, 2nd Lieutenant of the Army Air Corps, 0 2065589.

Generals called this a war of nerves. Guards tried to make him uncomfortable. It was part of their job. The nuns at Saint Ida's entered his consciousness, repeating *"Do not kill."* The etiquette of war didn't make sense. Soldiers were demanded to kill in defense of national interest. By navigating to the target, had Mac murdered? He had not fired a shot at a person. Was he excused from God's eyes from murder? What was war about? There was no "why" here. There were no answers. Anger arose. Everyone at home was comfortable. Why was he here alone, trapped, hungry? With an imaginary pencil, Mac captured the look, the likeness, that strange wildness in the guard's eyes. *Draw it again.* Thickness to thinness of line gave depth to nostrils, eye corners and ears. This kept the committee of a thousand voices and fears at bay. He drew for a tomorrow he wasn't aware of yet. Strength, purpose and true faith emerged from these dark shadows by tracing likenesses in his memory. During intermittent interrogations, he gathered more details for mind-drawing. He checked his proportions. Insights into gestures and expressions kept him observing intently. The drawing gave a purpose to this unearthly hell.

The interrogations went O.K. Mac was trained to give name, rank and serial number. "William Franklin McMahon, 2nd Lieutenant of the Army Air Corps, 0 2065589," adding "POW 9324." Nothing more. Entering office 47, Mac was greeted with, "Come in. I am your interrogator," said his German interrogator. Trained by Hanns Joachim Scharff, the friendliest interrogator who was effective in mining information from pilots over a beer in a tavern or walk in the woods, Mac's interrogator knew about their plane, Red, where it crashed and more facts about Red's crew than Mac knew. Mac's job was to tell the interrogator who leaned towards him with elbows on wide knees below a wide grin, "You have my AAF dog tags with name and numbers. They say, William F. McMahon, 2nd Lieutenant of the Army Air Corps, 0 2065589 POW 99324 and now a '*kriegie*'." *Kriegie* is shortened from *kriegsefangener* or "prisoner

of war" in German. That's all he said, over and over again. The interrogator unwrapped a loaf of white bread and cut it into two pieces. Mac was pretty sure he only said name, rank, serial number after tasting the bread. To become free of his cell, he tried to be more German than the Germans. To be more abrupt and in-control, more disciplined and more faithful to the Geneva Convention. He followed the code-of-conduct from his training without knowing its outcome.

Making images with no pencil or paper organized and calmed his mind. Some men's eyes persisted in looking outward; Mac had a way of looking inward to reflect the impressions that this astonishing world flung upon him. He would continue to look closer and closer at his surroundings, then reflect as he processed from within an impression of himself. Then, with more understanding of himself, to understand, more clearly, those over there. Cradled rifles with sights below the eye of a yawning guard in khaki. His intensity of gaze and inner reflection were trained to be indomitable. *Ask no questions.* There was no why here. Exhaling sighs of despair. *Dugaluft* days tested his hard-earned endurance. He had parachuted into a place at the bottom of Dante's Inferno, to the bottom of life itself. It was called Pirmasens, Germany, where he hid in a cave until arrested. Marched in and transported by train, Mac and other crewman, some from Red, were transported to the Oberusel's *Dugaluft* Interrogation Center north of Frankfurt. Repetition in tasks made a new world order. After a few fairly pleasant interrogations, the German leaned back and asked what Walter Winchell thought about the war. Mac perked up. Did Irv Kupcinet think the war was almost over? "Name, rank and serial number." Mac was presented his first Red Cross Package that was eaten before he left Oberusel. Red's crew members were marched for a three-day train trip to their camp except for the waist gunner, who remained talkative. They took the tram to Frankfurt station. Hitler Youth sang spirited marching songs until they saw the airmen and started yelling lewd obscenities with all the hatred they could rally.

The air raid siren blasted the icy air. Glass cascaded. Someone peed. These officer-prisoners were strong-armed into a bomb shelter by guards. Allied planes dropped their payload. Screaming avalanches shadowed the terrified crowd, racing for cover. The station shook, more glass cascaded, then tinkled. Explosions pierced their ears, thoughts, and heads. Walls vibrated and crumbled. *We could be buried alive!* Screams, moans, howls and sobs erupted then, roaring loudness reverberated. Furious, panicked civilians dove into the shelter. The *kriegies* huddled, trembling, tightly cramped with the Germans. Not every German felt good about Hitler, but hatred for Allied airmen fueled the villagers' stares directed at our American troublemakers that bombed civilians. Mac squirmed. Everything was inaudible. His eyes adjusted to the dark, and he glanced about, momentarily deaf, but aware.

A dazed gaze from an indigo-eyed nine-year-old boy in a Hitler Youth uniform stared back. A row of stoic uniformed boys, one straw-blonde with sapphire eyes, one white-blond with azure eyes, a cerulean-

eyed platinum blonde and another with sandy hair and cyan eyes staunchly poised on a bench. The boy shared his anxiety. They shared the silence. No one could hear. The majority showed flared nostrils beneath hateful stares. The boy wondered back into Mac's lake blue eyes over thinning tarnished copper hair. Being a *kriegie* was demoralizing. It stunned Mac's mind. An overwhelming hopelessness settled in his heart. Hope was only a dim, dim shadow tucked in a far dark corner of this crumbling confine. Strength, purpose and faith might emerge from that dark place. At first, it was easy to sit back, follow orders. The complacency of survival numbed any instinct to escape. The captors kept a close eye on their prized officers. Each was a potential font of information. Prodding, poking, commanding them resumed when the muffled air raid siren went silent. Still silence.

The Hitler youth's gaze broke from Mac's. The boys were harshly commanded to leave their shelter first; one spit at the *kriegies*. Citizens were directed to leave next. Prisoners were then prodded by rifles. More interrogations were scheduled. Mac's eyes adjusted to the cloudy gray sky. Throbbing injured inner ears made him dizzy. *Focus!* The blue-eyed blond boys stacked shrunken, burnt, stiff bodies in truck beds. Leaflets floated haphazardly up, then down, in the dusty air. The leaflets stated that according to the Geneva Convention, Allied prisoners were to be treated as prisoners of war but not enemy combatants and were to be fed as German citizens. *Kriegies* were fed as non-working poor Germans. "Any German officer or guard of any rank who treats a POW against the standards of the Geneva Convention will be tried individually." Why would the Allies think this warning would scare the Germans? Hitler controlled them. Germans suppressed their thoughts and followed Hitler and his laws scrupulously.

Mac stepped through the debris to board a train. Sergeant Hauptman commanded the pilot, Co-pilot John "Tex" Cornyn, the waist-gunner, Clyde Cottie, the engineer, Flake Dyson, the bombardier, John Nazarian, and the navigator, Franklin "Mac" McMahon, who parachuted from an exploding Army Air Corps plane called Red, off the train at Sagan station. Still, they pretended not to recognize each other to protect each other. Mac jumped down from the big-engine hissing train at Sagan station landing on frozen stones. His eyes took time to adjust to the gray, clouded haze of light. Mac was taken to a room at the station and given a blanket. With foreboding, the *kriegies* filed past a tall, lean brick guard house where their IDs were checked. They slogged up the sandy road for a quarter mile to the camp. Tall trees, planted in symmetrical rows lined the road like sentinels secreting a pleasant pine smell as they witnessed their captivity. Through the pines Mac got a view of the camp as he passed the ten-foot rustic fence made of split pine saplings nailed closely together leading ahead to the main gate. A huge crimson sign emblazoned with a black swastika hung limply from a pole near the Vorlager, the German administrative building, a small hospital, and a cooler at the entrance of the camp. Through the enormous gate on his left, Mac could see clusters of green-gray weathered barracks, a barbed wire fence and elevated wooden

guard towers. Stumpy trunks sat between the maze of barbed wire between compounds and the forest. Guards swung open the gate and peremptorily checked papers. The cluster of men was paraded through in low spirits as the gate shut abruptly behind them. Warily, Mac looked around at his compound. Three hundred yards square with two fences about ten feet high and five feet apart around it. Each fence was strung with twenty closed strands of rusted barbed wire. About fifty yards behind these fences stood the "goon-boxes" on stilts fifteen feet high, with guards behind with search lights, machine guns and phones. German guards pointed their weapons from towers in greeting. Thirty feet inside the barbed wire was a warning wire about eighteen inches high. Everything was gray. Gray faced men in clothes tread on gray earth and worn floors in aged barracks. New *kriegies* were herded into a forecourt of a stark one story building. The men were led in one by one for processing an ID and given a metal identification tag stamped *Stalag Luft III* and his POW number.

The men, showered, were dusted for fleas and lice from a Nescafe can punched with holes over a cold water pipe. Mac was issued bedding—a thin wool blanket, one sheet, one mattress filled with wood shavings, one pillowcase, one small linen towel and one pillow filled with straw. Also, a two-quart mixing bowl, one cup, knife, fork and spoon were given once and not replaced. He was handed a paper package with a bar of soap, razor, cup, bowl and spoon, all tied with a cotton string in a knot. This, the silk map still in his sleeve, and his clothes —minus one boot, was his list of items owned. Everything was a shade of gray, as if a veil had dropped over the colors of the world. He unwrapped the paper, coiled the string and put both in his pocket.

Kriegies were called to attention as a Luftwaffe officer strutted to welcome them with an American service officer, who led them off for a talk in the theater. From gate to theater for a one hour briefing on how camp was organized, camp activities and regulations. Mac and the others were marched to the mess hall for German rations. Current prisoners pooled their Red Cross parcel items to augment, feeding incoming men. They knew their deprivations. The *krieges* were taken to a leader and marched through 10 feet-high double barbed wire fence to West compound and told to find a place to sleep. Wary Americans tested him with history and sports trivia to ensure he wasn't a German spy in their barrack. Mac tossed his mattress and pillow on the wooden surface. It was more of a wooden shelf built of four-by-fours, three platforms high. He saw the other POWs had woven together pads of scavenged paper, like scout campfire pads, to cover the straw mattress. That first night, with the stoves flickering, he considered what he'd become in two short weeks. Would his foot fester with infection? *Heimweh* was the German word for longing for one's home. Listening to the conversations around the stove, Mac picked up a burnt stick. Unconsciously, he drew the Texan across from him with the burnt tip on the wooden floor.

"Ya frickin' Mac?" whispered a seasoned POW who bumped his shoulder during barrack's check.

"I'm Mac, why?" His mouth was dry from not speaking.

"Don't ask, just meet me at the last lunch table on the right...And bring your map." Long, moaning train whistles wailed through the bare trees and waning dawn from the valley below. A lingering line formed out the unlocked splintered door for breakfast.

"Shut the door, it's freezing in here!" Lunch was soup, a big bucket of soup. POWs shouting inside, "Frickin' stir it up!" to get some of the solids to float up. In line, Barney stood close when another guy lit up a cigarette, to breathe in the airborne smoke.

"Flick off!" *Kriegies* didn't share cigarettes. Barney waited, hoping for a puff. He traded his solid vegetables for cigarettes. When he couldn't get a smoke, he traded more solids from his soup. *Barney's wasting away.* Mac looked for the last table on the right. These are the gray souls that survived. They bore witness to those who had been lost to a darker and more pitiful remembrance. There was not any radiance in that soup line. At best, all eyes were infused with a wildness, a fatigued survival. All eyes seemed to emit an acquired sorrow. A quick glance up above a soup bowl let Mac know he'd gotten to the right bench.

"So, you know how to draw?" The question was whispered to the soup bowl.

"Yah, cartoons mostly," Mac answered.

"We need your map. Cassie will show you the ropes and give you some work."

"I need my map," he stated.

"Just give us the map. You'll get it back, if you're lucky."

"O.K., I want my map back," Mac repeated. "Do you have an extra left boot? Size nine."

"We'll get you a boot."

"And a sock," Mac bargained and was welcomed into the smoke-filled room of the underground political system that had been organized into an intricate pattern of patronage and cunning. He handed over his silk map that removed the veil from the mechanism of this clandestine defiance and survival organized by an international group of leaders. The POWs printed copies of his map in with a handmade press, a clothes-washing wooden roller with blanket squares. With a strip of blanket and ink made from fat-lamp black mixed with neat's foot oil impressions of his map were transferred. A fair-fitting boot and a sock were dropped off under his bunk. No laces. He heard the twelve surviving Tuskegee Airmen were divvied up in different barracks, including Lt. Alexander Jefferson from Detroit. Barney gabbed about the seventy-six escapees from *Stalag Luft III* via an elaborate tunnel, civilian clothes and false identifications. He showed Mac the monument the POWs erected for them.

"That's where our slats went-to shore up the sandy tunnel. It took seventy-thousand police to search and find all but three escapees," Barney said. "BBC reported forty-seven of the re-caught prisoners were

shot while relieving themselves by the side of a deserted road. Three more were murdered elsewhere." Mac fought the biting cold at the stone memorial built to honor the 50 murdered escapees (from *The Great Escape*), as signed on a cartoon by First Lt. Alex Cassie. He was content to be safely confined. Mac secreted a shell around the rock that was him and his art making after meeting Carl Holmstrom who handed out YMCA art supplies. He felt his edges worn smooth day by day. He felt the ripple effect of his actions. Adapting passively and unconsciously to a world divided into separate layers of survival systems, he hammered a nail where his head rested to hang his boots at night. He avoided conflict with his bunkmates with humor over his little clutter of possessions. He lined up for soup and bread without complaint. He kindled friendships in French. *Who'd want to avoid Barney? He was harmless.* Mac nurtured his compassion. His heart started breathing. He found ideas for ideas for cartoons, which he sent back to *Extensions* magazine in Chicago. The cartoons somehow bypassed the censors. He drew a guard, then another and another. More paper was picked up from a guy called Mutt. He drew Kommandants from the shadows. He escaped into his art, into the created image. Reality was restored, purpose achieved, freedom in art discovered. His heart and soul relaxed.

"*Achtung!*" Shiny buckles and pistols stomped into the barrack unannounced. A switch twitched in the ferret's leather gloved- hand to lift blankets and loose clothing. Not one scrap of paper was found. Mac's charcoaled sticks were hidden in a hollowed bunk-post. The outer walls of *Stalag III's* barracks were doubled years ago. The half-a-foot of space behind the false walls concealed tools, tin cans, dyed cloth and thread. "Pack your things!" the guards commanded. "We are marching at 11:00 p.m. sharp." It took until the following afternoon for his barracks to clear *Stalag III* gates.

"Be careful what you wish for," his commander said. "It could get worse."

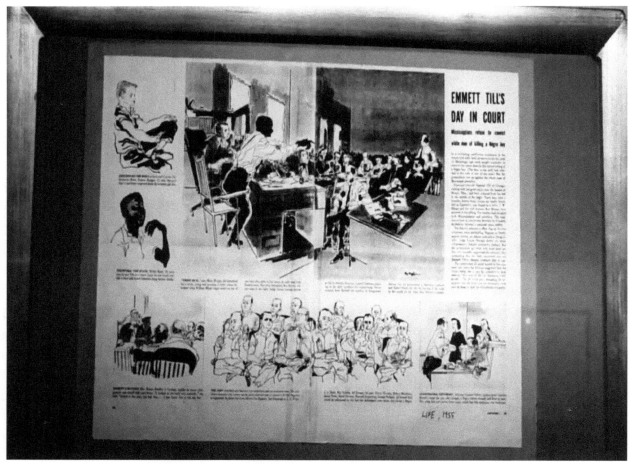

1955 *Life* article with Franklin McMahon's drawings of the Emmett Till Trial

1950s—The Emmett Till Trial

The oppressive, heavy air woke Mac before dawn. Not even the starlings had begun their early gurgling and disjointed harsh chatter. The sullen air over-rode the cheap and sputtering window air conditioner that strained to lift the humidity while barely puffing cooler air in lazy circles through the thick and slow aura. There it was. The first bird's shrill sliding whistle of the day, rhythmic, echoing and distant. Ahh, that's the one that will get the worm. In the dark, his bare feet stepped onto the worn carpet and he opened the wide mouth of his leather aviator bag. In boxers and a v-necked T-shirt, Mac carried his toiletry bag to the sparse, plastic-tiled bathroom. After a steamy shower, he

18

wiped dripping condensation from the tin-framed medicine cabinet mirror. It's just another job, he told himself as he lathered the bar of shaving soap, leaned into the cracked mirror to cover his jaws, chin and under his nose with white foam. He lifted his chin and daubed the foam above the jugular and back to the base of his ears. His silver two sided and dulled razor scraped a red path through the stubble. The other side was not much sharper. Recalling from the previous night that sideways look of the poker-faced night clerk as he peered at Mac's brown paper package under his right arm. "Wellllcum to Summmner," he'd been friendly enough, though his southern accent, with elongated syllables, took a little concentrating to discern. His package had slumped into the front desk when Mac set it on the toes of his Oxfords to sign in at the motel. "Ouch!" A spot of red dripped through the foam as the razor nicked the edge of his jaw. He dabbed the spot with some toilet paper, leaving it sticking out on his face while the razor continued to graze through sequential paths. And the cab ride from the airport, "What brings you to Mississippi?" the driver had tried to carry Mac's 2-by-3-foot flat, but bulging, brown package, into the lobby. "It's a bit heavy," Mac coveted his package of drawing pads, pencils and ink pens while keeping up a friendly banter about the heaviness of the night air. The cold splash of water stung his freshly shaved face. Maybe I'll take the smallest drawing pad and blend in with all the reporters. He sat by the waste basket pushing the sharp one-sided razor through the soon faceted wood and graphite of his veri-black pencil, then lightly shaved a sharper point. Another pencil and another were sharpened by hand until he filled the breast pocket of his white dress shirt. These would hide beneath his suit coat. The inside suit coat breast pocket held his press credentials from *Life* magazine.

It's too early to call Irene, he thought. *Maybe after breakfast and before the kids are awake.* Mac pulled the rubber eraser apart, squished it together and pulled it apart to clean it from yesterday's erasure. As dawn lightened the sky through the narrow blinds, Mac slipped on his suit, tightened his knit tie and went downstairs for his continental breakfast of coffee, toast and orange marmalade.

"It's a bit sticky," Mac summed up his impressions of Mississippi to Irene over the lobby telephone. She was distracted by her oldest, elementary-aged son who had just spilled his cereal bowl to interpret what this might mean. The twins were stiff-legged climbing up, then jumping down the two living room steps. The middle boy had slid in his stocking feet down the concrete ramp into the kitchen, climbed onto the chair rungs and was staring straight into her face. By the windows, a pre-school daughter was quietly weaving nylon loops on a small red frame-probably making a potholder. Nearby, a toddler was taking cautious steps from the coffee table to the couch, then to the cyprus window frame. He slipped down and began to cry, looking at the splinter in his finger. Most had eaten breakfast already.

"You're up bright and early! What time does the trial begin?" she asked. Irene didn't know yet that she would miss this closeness, knowing where all her children were at a glance. "I'm headed over to size

up the place and see if I can get a start on drawing the courtroom," he replied, hearing the baby's sobs in the background. The phone line started to crackle.

"Keep in touch," she replied as the milk flowed off the edge of the table and across the concrete floor. She had barely finished sanding the Cyprus beams of their newly built home when Mac landed in Sumner County, Mississippi for *Life* to cover, with drawings, the Emmett Till Trial. *These Southerners are still peeved about last year's Brown vs. the Board of Education decision*, he thought as he stepped out into the dusty dawn. He was only a few blocks from the red brick county courthouse with a clock tower that was sounding 6:30. A few police were chatting by the front door but were not letting reporters in until seven. Across the street, Mac drew from a coffee shop the arched windows and doors of the courthouse on a small sketch pad that fit in his inner suit coat pocket. As soon as the doors opened he flashed his credentials and found a seat in the middle of the still empty, white press section. With his sharpest pencil, he drew the jurors' seats, the witness stand, the door to the chambers and judge's seat with U.S. and Mississippi flags on either side. He was drawing the stage set for the what would become five days of court theatrics and sixty-seven minutes to a jury decision.

He was jostled as the press section began to fill and the spectators shuffled into the courtroom and gallery seats. From a lone crow to a sparrow amongst a flock of birds, he mused and erased a stray line caused by a reporter who bumped his elbow. *We're perched here like a flock of sparrows on a wire.* "Eh Mac, sorry," the reporter said in a distinctly Chicago accent. *The less said, the better with us sounding like that.* He redrew his line, then glanced around to see several reporter friends from Chicago settle into seats.

Okay, relax. Let it flow, stay alert. Where's the story? Nah, the segregation in the courtroom or the press sections is not news. His pencil captured the body language of a coiffed and elegantly dressed Mrs. Bryant in his hand-sized spiral notebook. The heavy heat in the crowded room evaporated. He focused. Fourteen non-sympathetic and arrogant white male jurors set the tone with a wash of ink. Their likeness and lackadaisical body language slumped in wooden chairs. *Leave out the juror's beer, it's judgmental.* He didn't feel the heat, though he'd already soaked his T-shirt and dress shirt as the hopeless fans noisily churned above. The story unfolded about Emmett Till, a visiting black 14-year-old from Chicago. Emmett had been taught to whistle to calm his stuttering. After struggling through b-b-b-b- to ask Mrs. Bryant for bubble gum, he let out a bit of a whistle to calm down. Accused of flirting with a young, white female grocer, Emmett was abducted from his uncle Mose Wright's home, and his cousin's bed, a few nights later. Sighs were breathed in the upper balcony seats. Chairs moved on wood. The nephew, son, still-a-boy Emmett was beaten in Leslie Milam's shed, shot and mutilated, then found in the Tallahatchie River. Pencils slowed in the Negro press section. Rustling of fabric from the gallery was almost a squirming

silence. Not a breath was drawn from those in the rear seats. Then it happened! "Can you identify the men who came to your door?' Graphite that scratched the texture of paper interrupted the vacuum of breathing as Mose Wright stood up. With a shaking arm, he pointed to the white men, Roy Bryant and J.W. Milam, "There's he." Mac's pencil flew to capture the tension in the air. *He just shucked off 300 years of United States history.* Mac's lines captured the electricity in the room in the form of the shaky, outstretched and elongated arm, the force of gesture in the stance, the suspenders on the pants. Then, with a loud lurching thud, Mose Wright sat. That told what strength it took him to stand, point his finger and state two words. The Judge's gavel echoed in the thick air as he called a recess. After coming out of his drawing, Mac folded up his pad, tucked his pencils in his breast pocket. He and another reporter silently walked across the street for a cup of coffee. At the coffee shop door, they were surrounded, closely, by a few white male citizens, "You Northerners go back home and leave us Sumner folks alone." Shirking off the comment, he decided to get coffee at his hotel.

In his hotel room, Mac redrew the sketches on larger sheets of Arches paper. *Got to get the quiver from the rear gallery in his spine.* His hand shook. *Life* had a tight Saturday night deadline. Getting the art finished on time took long nights and early mornings, then days for the mail. Mac mailed the notebooks and drawings in the brown, flat package from the hotel desk directly to a New York City address. He sees from the corner of his eye the *New York Times* on the desk with the headline, "The First Time in Mississippi History a Negro testified against a Sumner County citizen." *Ahh, they beat me to it.* The cab picked him up at the motel door for the airport with only his aviator bag in hand, not knowing if his drawings would be published. Mac realized then that art could effectuate social change.

The *Life* magazine Emmett Till Trial article also changed a cartoonist father into an Artist Reporter, a chronicler of his time. A few months later, when Rosa Parks built up the courage to stay seated sit in the designated middle of the bus when a white person demanded her seat, she thought of Emmett Till and stayed seated. From the jail, she called Reverend Ralph Abernathy. Reverend Ralph Abernathy called Reverend Martin Luther King Jr. The Civil Rights Movement peacefully began with a one-month bus boycott. Blacks walked to work while the city's bus system lost revenue.

Margot on Mayflower

1960s—Snug as a Bug in a Rug

Being lucky, number seven of a family of nine had more benefits than losses. I was head of the little kids' round table, a short Formica table next to the hum of the refrigerator. My back was to my mother, who passed dishes for me to serve my younger brother and sister. The older six sat with our parents, and usually a grandmother, around a very long wooden table with crossed legs. "Mac, please pass the mashed potatoes," she said. One Saturday, Dad and I picked a length of the demolished bowling alley on Western Avenue in downtown Lake Forest. He rested the bowling alley, dings, divots and all on two antique cast iron sewing machine footings to include us little kids in the conversation.

Always a bit over my head, I was brought into our true inheritance, growing up in the 1960s with an artist reporter father and writer mother. They were in the heat of the troubles capturing the scenes

22

of chaotic protests for social justices: women and gay rights, freedom of speech, workers' rights, racial equality and anti-war. By the time I moved to the big table, I had lived in three homes, one in Spain, survived a tornado on my first sleep-over and Stormy, our dog, died. My two oldest brothers opened space at the table by going off to boarding schools. Gramma Mac passed us JFK half dollars and moved to California to remarry. The first Catholic President of the United States was elected, and we were told it would be good for all of us. Most of what was said, I guessed at its intent.

I sat facing the eight-burner stove with five ovens for the next dozen years, circled by toddlers to teens. John, the youngest, sat across from me and Jean, Elizabeth, and Hughie next to him, faced the broad white sink and window into the maple shaded side yard. Mom and Dad sat at the ends with Gram Leahy, Mary, and Patrick next to me. We were drawn together into a tight circle by the trouble, good trouble, from the outside world. Occasionally, the conversation was about whether Hughie or Pat would mow the yard's small lawn with a push mower. As most conversations went, I don't recall the decision, but the argument was it was easier to use the gas driven large mower. What infiltrated into our circle that kept us relying on each other were images of current events with guns, soldiers, mace, barbed wire and walls. Dad sat quietly at dinner after just returning from Berlin, with a brown paper package of art slumped against the cupboards behind him, until Mom cleared the plates and began to serve dessert. Dad leaned back to pull his paintings from the worn package and tell us about Berlin.

"I went back to Germany as the wall was being put up to divide East and West," Dad explained, "They were stringing the barbed wire along buildings." In 1961, Dad made some drawings of the Reichstag building, which fell into disuse after World War II because the German Democratic Republic met in East Berlin while the Federal Republic of Germany met in Bonn. This went on for ten years until Khrushchev in 1958 demanded a "Free City of Berlin" and the withdrawal of Allied Military forces. At this time, the Soviet policy declared East Berlin as the capital of East Germany.

"I don't know anything about Germany, but why would anyone build and guard a wall?" I asked. It was beyond my understanding after a day of exploring wide-open three-acre properties, ravines and beaches. Outside the window, the backside of a neighbor's new wooden fence kept me from visiting the girl next door whose family rented a coach house on the estate.

"While I was scouting my next drawing of the barbed wire wall, a German policeman pointed his gun at me and spoke very loudly about my being on the east side of the wall," Dad said. "I shrugged my shoulder and said I was a 'dumb American.' He waved the shaft of the gun to indicate I could go back to the west side." Dad turned around and lifted his drawing out of the brown paper. Pencil lines on heavy paper showed spiraling barbed wire on blocks of stones that made up a wall. Solitary guards with long coats and rifles walked along the wall on rooftops. I learned later the Berlin Wall was built in 1961 to

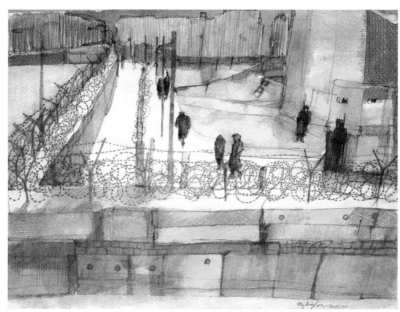

Berlin Wall (1961)

divide East and West Berlin. A decision made September 12th, 1944 at the end of World War II was revealed. Once allies, the Soviet Union, United States, Great Britain, then France, met to draft a treaty that would divide defeated Germany into three parts, sowing seeds of conflict. In the mid-1940's the Soviet Union disavowed the section of the agreement that declared Berlin a separate occupation zone. The Soviet Union continuously worked to dislodge the Western Allies; Britain, France, Canada, New Zealand, Australia, South Africa and the United States, from Berlin. Delivery of food and coal were severed when the Soviets stopped all their supply trains. The Allies' supply trains were blocked to East Berlin. The Western Allies airlifted coal and food with up to 927 flights a day into East Germany.

By 1949, the airlift was succeeding with more supplies being delivered than previously had been by train. In May, the blockade was lifted and Germany divided into the Federal Republic of Germany(West) and the German Democratic Republic (East) through the city of Berlin. Though any official statement declared nothing is going on between East and West Berlin, plans were being made for a fateful night of Sunday, August 13th, 1961, when four divisions of the People's Army placed barricades and barbed wire to divide Berlin.

With a shortage of supplies, the elite professionals in every field found a way to move to West Berlin. To compensate, the "Candy Man", Gail Halvorsen, an Allied C-47 pilot, dropped chocolate bars tied to handkerchief parachutes for German children in East Berlin. To distinguish his planes from the others, he wiggled the plane's wings, earning him the nickname Uncle Wiggle Wings. Other pilots followed his example and became known as the Rosinenbombers or Raisin Bombers. This expanded with officer

approval into Operation Little Vittles that dropped 23 tons of parachuted candy in various places in Berlin. That Christmas, Dad gave Mom her annual one- hundred single dollar bills in 100 helium balloons and handed the nine of us hat pins to pop them raining bills for us to catch and scramble to gather.

"I left my drawing in the hotel and caught a tour bus at the zoo to see the Russian Monument to the men who died in the war on the east side. The bus stopped at another hotel and picked up several passengers, including Satchmo Armstrong," Dad said expecting us to know he was an important grown up. I tried to ask a question but couldn't find the words to use.

"Everyone on the bus was in a tizzy about Louie Armstrong being on the bus as we went through. The bus tour went to Checkpoint Charlie, a kiosk-type building placed in the middle of the street. The road was configured like a snake with barricades before and after the building. It wound its way from the West past the wall and crossing point. The tour showed famous places of East Berlin, including the Soviet War Memorial in Treptowers Park commemorating 5,000 of the 80,000 Soviets who fell in the 1945 Battle of Berlin. The tourists, Dad and Satchmo included, walked around the Soviet Memorial, but Dad didn't draw. "I didn't want to risk it, but wished I had drawn Louie Armstrong at the Soviet monument." Mom had everyone pass the dinner plates to scrap the scraps on her plate on a stack of the

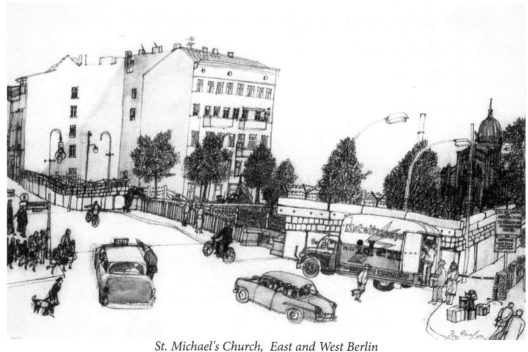

St. Michael's Church, East and West Berlin

others.

"The great, big bus zig-zagged back through the winding barricades and past the armed guards at Checkpoint Charlie. The jazz musician still had everyone's attention when a woman got up and said something to the bus driver," Dad said. "The driver pulled over and looked both sweaty and ashen. He announced something in German then said in English, 'It is good for this woman that she has just escaped East Germany, but it is not good for me. When we got across, the soldiers got onto the bus to check everyone. They were thrilled to see Louie Armstrong," Dad said. Dad pulled two more drawings out of the brown package. One was made of just a few lines that made up an empty city of rooftops and a man walking in the distance." Another drawing showed the wall going right through the middle of a Catholic church called Saint Michael's. I still wonder if two priests say two Sunday Masses on either side of the divided altar? From 1949-1961, 2,689,922 people fled from East Berlin to West Berlin by official statistics. The real number is probably significantly higher.

The wall divided St. Michael's church in two, half on the east side and half on the west side of Berlin or subway offered access to the west. If one didn't take too much luggage, they might make it through unnoticed. If they did get caught, the refugees would suffer three years in emergency camps. The refugee flow exceeded the capacity of camps in West Berlin holding 3,000 beds. Many of these were scientists, doctors, engineers and senior managers and huge amounts of well- educated twenty to thirty-year-olds. This caused an economic bottleneck and extreme measures had to be taken by the east. These escapes started to be in trains, then out of windows of buildings that made-up part of the wall, but escalated to people hanging below cars and trucks past Check Point Charlie.

Hiroshima, Japan

Cocooned within a large family made it seem commonplace for my parents to fly around the world in my first few months of first grade. Sister Mary Michaelina led us in prayer to Saint Mary every morning after the Pledge of Allegiance to the flag of the United States of America. My prayers were answered when Mom arrived home after three weeks, saying, "I missed you so much, I came home early." Did she fly the rest of the way around the earth or return the way she came? Dad came home soon after with another brown paper package slumped behind his seat at the end of the bowling alley table. The drawing that came out of his package was of a blown-up building with a remaining domed

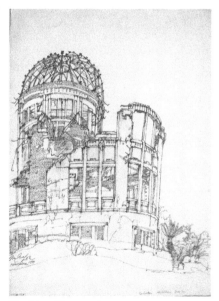

Hiroshima Monument

top. "The atom bomb was dropped on Hiroshima that ended the World War." I thought of the stink bomb mushrooms in the woods outside that exploded into zillions of tiny particles. Then tried to imagine one explosion that would do that to a building and end a world war. He came back with a different way to hold a paintbrush above his painting with a fluid wrist action. The wet paint flowed to the tip of his brush.

Drawings that captured scenes in the world came to the bowling alley table. Dad's images and Mom's writing expressed the emotions in the conflict, the immediacy of people making up a crowd. Many of those protesters are shown for the story they carry, the choice to leave their children, parents to be a part of something bigger. They showed violent protests in Chicago's Marquette Park. MLK speaking to tenants in slums on West Madison Avenue in Chicago, JFK being killed in the South and LBJ becoming President. LBJ and Bobbie Kennedy disagreeing from afar until it all came to Chicago, one Midwestern city profoundly split in two at Division Street, America.

Mom and Dad went to report on the nonviolent Selma-Montgomery march and the John F. Kennedy Space Center Gemini Program launch. With a press pass, Dad joined his Catholic clergy friends to drop into Selma to draw this moment of history. Mom's empathy gave her the courage to let him go, then decided to join him. March 7, 1965, the television penetrated into our home, showing the Edmund Pettus Bridge police attack on peaceful southern protesters who wanted to vote on "Bloody Sunday." Police on horseback chased unarmed, elderly women and children, beating them with bully sticks. They were there to terrify, but the sticks cracked skulls. The protesters were herded into a black enclave of three

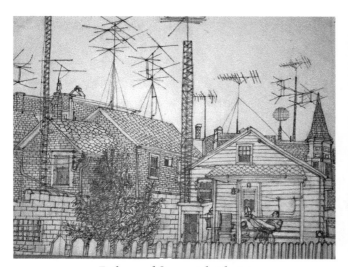

Father and Son watch television

Father goes to work with Child watching

brick churches and a row of public housing. Dad heard that protesters escaped into a church only to have firecrackers thrown through the windows by police. An older woman who fell in the melee had a lighted cigarette burnt against her buttock. Children were left home alone.

Monday night, a young Unitarian divinity student who was active in enabling black voter registration was cornered and beaten to death. Father Jack Egan made it clear that no clergy or nuns were to step outside alone and without their collar or habit intact. Within the circle of the Catholic clergy, Dad created a safe, protected corner to draw the Civil Rights Movement while Mom wrote her impressions. By Wednesday night, he was in a church jammed with civil rights characters and locals. They held hands in the cross-breasted custom with laborers who had broken hands and slinged arms to sing "We Shall Overcome." At Holy Communion, Dad was moved by the protected white cleric with smooth and scholarly palms,

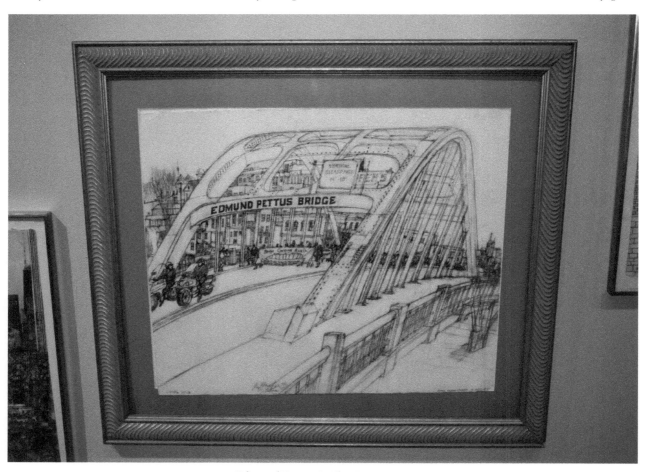

Edmund Pettus Bridge Reenactment

connecting to the brave working man who wore bib overalls and denim. Thursday, Friday, and Saturday, blurred.

Dr. King was on his way to Selma, but everyone else was there, staying in houses and apartments, being fed by traumatized young teenagers whose parents and grandparents were hospitalized or jailed. There were many meetings for careful planning of the next march. Dad was fascinated with the intense basement planning meetings with crucifixes glinting at the end of rosaries. He made a drawing that included Reverend Robert L. Powers standing within a group. Reverend Powers told his family, "I met Archbishop Iakovos. [He] appeared on the altar platform of the church for one of the rallies of song and inspirational witness." The crossed arms were tricky for him, as he propped his Archiepiscopal Cross in a bobbling arrangement between his elbow while swaying back and forth. Dad told me he was grinning, as if no liturgy he had ever known was as wild and as much fun as this one. The Archbishop was a beautiful sight in his tall crown and veil, and a worthy successor to the Apostles. Sunday, Dad watched small groups that went out to attend services in local churches, but were blocked from entering. They knelt on the pavement outside for prayers. Dr. King came and inspired the clergy, Northern protesters, Southerners hoping for voting rights, children, grandparents, angels and archangels and all the company of Heaven. Dad joined the masses that gathered and sang "Holy, Holy, Holy is the Lord of Hosts. The whole earth is filled with His glory!" He was careful to draw from a corner to not be noticed.

At dinner, Dad told us about being on a bus full of singing and shouting demonstrators in Montgomery. Outside, a group of Southern white men, carrying torches, started to rock the bus. Dad stood up, raised his hands and calmly reasoned with the Northern protesters to stop singing. They quieted. The rocking of the bus subsided. The perpetrators moved on and the driver hurried away. *Forgive us our trespasses as we forgive those that trespass against us.* Mom and Dad published an article about the Gemini Program space launch that was testing two astronauts, Gus Grissom and John Young, as they orbited the earth three times, tweaking their direction by firing thrusters and presenting the question if we could do that on Earth with the Voting Rights Act. My family was held tightly together by that strife that loomed outside our home's walls.

By the end of the 1960s, Dad was listening daily to Studs Terkel radio show while painting, Chicago was the nation's epicenter of racial divide. With the most restrictive housing covenants confining South and Westside people of color to divested neighborhoods, then raising their cost of rent, gasoline and food enhanced an oppression that was stifling.

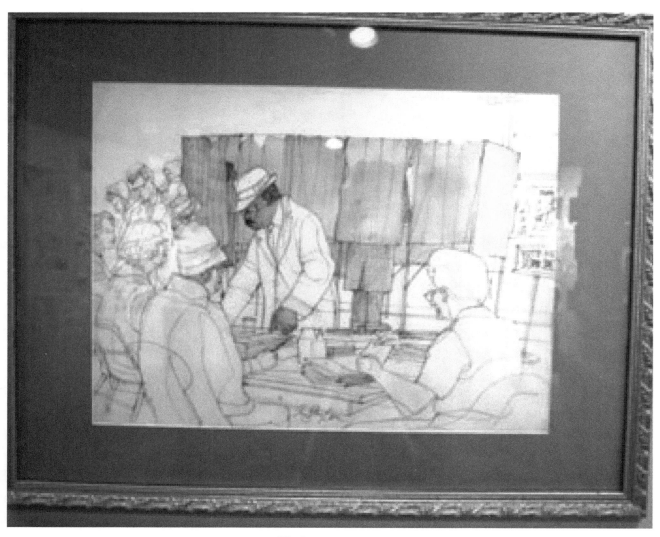

Black man voting

Bobby Seale gagged and bound at the Chicago Conspiracy Trial

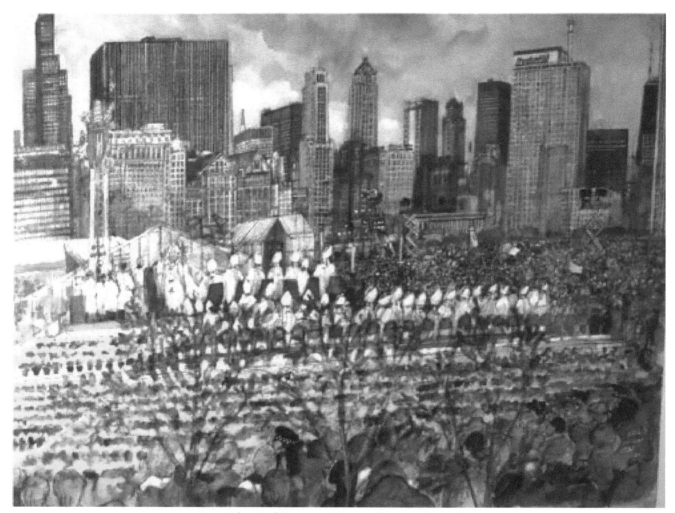

Pope John Paul II saying Mass in Chicago's Grant Park

1975—The Impossible Dream

The stories Dad had told us around the bowling alley dining table evolved into film making as their nest emptied. While I was in high school, Mom and Dad hosted a Film Club with friends from the Institute of Design. I stood in the doorway of his studio while a silent black and white film titled *Mrofnoc* looped noisily through a projector. In the scene, one man walked backwards down a busy urban sidewalk, purposely looking over his shoulder while the crowd avoided bumping into him. He was conventionally dressed in a suit coat and tie, nice Oxford shoes and trimmed hair, no beard.

32

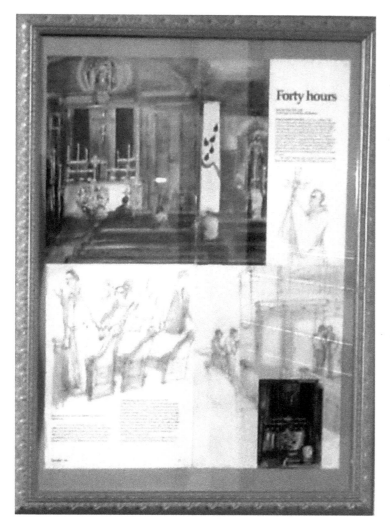

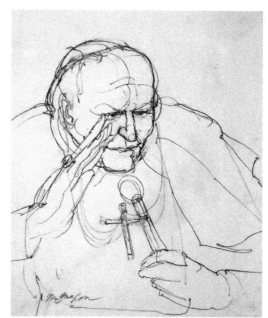

Pope John Paul II saying Mass at the Vatican, Rome

Catholic anti-war fasting protest

Transitionally, the man turned to walk with the others, then backwards, then fit into the walk with the flow of people. The last frame reversed the title to "Conform." Though I missed their dinner discussion, I summarized the film statement to be how one person's actions against the grain of society would affect everyone to question our treadmills of life. It is harder to walk backwards against the flow, but it might encourage everyone to question conventions with individual thoughts. Inevitably, we all adjust to join the flock. Dad transformed a room next to the kitchen for Rocinante Sight and Sound, his film business.

A movie crew filmed and edited Dad's artwork in his studio. The camera man panned across and zoomed into his painted cityscapes, crowds and events to show how it felt to "be there." His actively drawn lines captured the energy of the room and the cadence of the music. Mom interviewed and taped people's

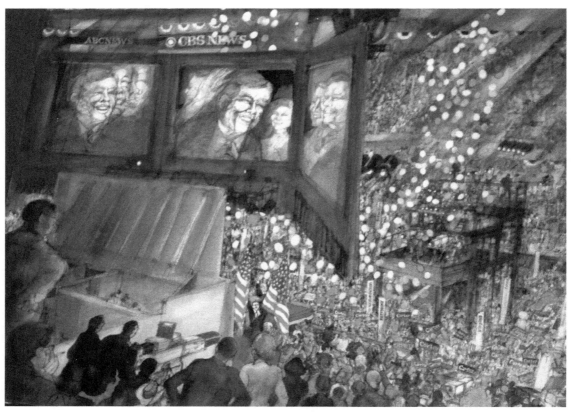

Jimmy Carter's Inauguration

reflections for voice-over impressions. In "American City at Christmas Time," Irene's taped voice-overs and Dad's art told a broader audience of their experience at a cathedral mass blessing and of Reverend Jesse Jackson chanting with prisoners in a jail, "I am somebody. I may be poor, I may be unemployed, but I am somebody!" on Christmas Day.

One Sunday evening after dinner, we all walked along the wooded path to our neighbor's home to watch his film on their color television. We crowded around the giant color screen with built-in console speakers to watch their first movie on WTTW that earned him a Peabody Award. The *Real Violins* film captured the Chicago Symphony Orchestra being recognized as world class under the baton of Sir George Solti and Dad as it toured through Europe, and then Japan, as the Symphony cemented its reputation. Not knowing where they had gone that night in formal gown and tux, we watched the Emmy Awards on our black and white television. Hooting and hollering exploded when Dad's name was called as he rose to thank his wife and collaborators.

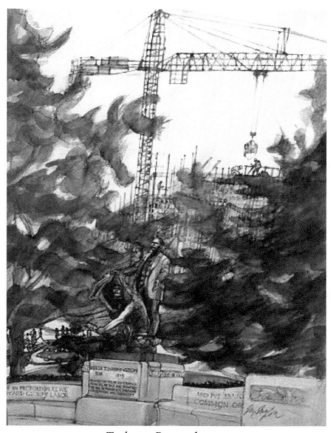

Tuskegee Remembrance

1980s—And Beyond

Though I watched the play, *A Raisin in the Sun* in Connecticut's Yale Repertory theater, it resonated of home, Chicago, and its discrepancies. It was no surprise that I learned the narrative story was about Chicago's Southside and a black real estate agent wanting to move a few blocks.

"Yale or Jail?" Jesse Jackson chanted from Woolsey Hall auditorium while I was in graduate school in 1983. "It costs more to jail a young black man than it does to send them to a year of education at Yale." The War on Drugs was escalating. "Yale or Jail" reverberated through my mind continuously as Nancy Reagan told young people to "Just say No!" After landing at O'Hare Airport in Chicago during my holiday, Lorraine Hansberry's story played out on the moving walkway from Terminal C. Everyone had arrived to their destination and many stood, allowing the walkway to deliver them to their changed objective. Let's call the objective a societal change away from systemic racism. Others briskly walked with their

suitcases-on-wheels to get there a few minutes sooner, bumping shoulders, rolling over toes with a hurried urgency. Then came an anti-person against this flow, walking against the direction created by the walkway and those headed to reach a more just goal. The anti- person chose not to weave around people walking against the moving sidewalk, but trip, knock, disrupted everyone in their contrarian motion.

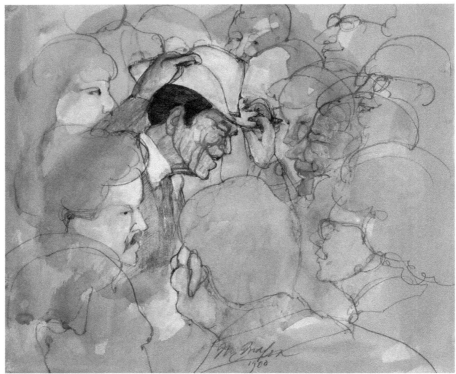

Ronald Reagan campaigns for presidency in 1980

"He is a radical!" Dad called out when I visited for dinner throughout the early eighties. Dad could be found calling out at the evening news as deep-seated change took place during the Reagan Administration. Was he talking with Mom, who was fixing dinner in the next room? "After risking our lives for our democracy, who let in a guy to take away people's freedoms? I was a P.O.W. with the guys he is sending to jail." Governmental infiltration of drugs into divested neighborhoods of cities nationwide created the War on Drugs problem with a solution being to incarcerate drug dealers who were "employed" younger and younger.

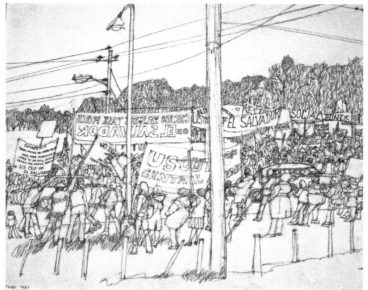

El Salvador War Protest at Notre Dame

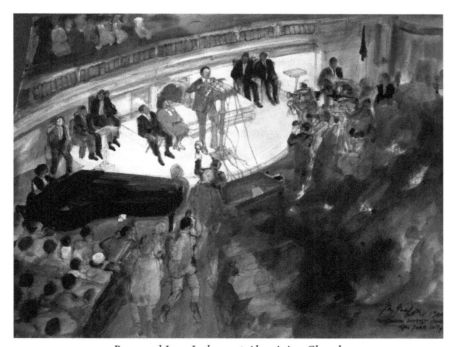

Reverend Jesse Jackson at Abyssinian Church

1995—Meeting His Age

"Irene and I went back in 1990, shortly after the Berlin wall was taken down," Dad said, "I didn't know how long it would be like this." October 16, 1995, seventy-five-year-old Dad joined nearly 900,000 men from across the country to gather at the National Mall in Washington D.C. He boarded a bus in front of Saint Sabina's with Father Michael Pfleger carrying his duffle bag and brown package of drawing materials. Minister Louis Farrakhan of the Nation of Islam organized and hosted the protest opposing systemic racism and called for a revitalization of communities of color. Men who could attend stayed home from work, as did their children that day. Reverend Jesse Jackson, Rosa Parks and Dick Gregory spoke to summon black men to "bring the spirit of God into your lives." And to vote. Maya Angelou read poetry, Stevie Wonder performed music, and Dad drew and painted. He drew participants as they pledged to support their families, refrain from violence and abstain from drugs and alcohol to concentrate on building black businesses in their communities. Dad returned home to a long recuperation after the exhaustion of the trip. He didn't mention where or if he slept, ate or rested. "I met my age on the Million Man March," was all he said. "I started to age then." The black community gained 1.5 million more registered voters and an upsurge in black children being adopted.

Five years later, Dad's friend, Monsignor John Egan, laid in his casket with shoes too big for his height at his Holy Name Cathedral Irish wake. Dad, my husband Dan and I sat halfway back in the pew after a wake viewing before his funeral. "Those big shoes at the end of Father Jack's casket make an impression," Dan said. Dad had drawn and painted his shoes at Edmund Pettus bridge protests and voting rights locations, church basement meetings, and at Johannesburg and Capetown to advise the South African Civil Rights movement in the fight against apartheid. Monsignor Egan's consistent advocacy travels for the Civil Rights Movement, for fair housing, opposing segregation and racism was often accompanied by Dad, who drew the historic moments. In South Africa between 1960 and 1983, three and-a-half million black Africans were removed from their homes and forced into segregated neighborhoods as a result of apartheid legislation in some of the largest mass evictions in modern history. Most of these targeted removals were intended to restrict the black population to independent states. The government announced that relocated persons would lose their South African citizenship as they were absorbed into the *Bantustans*, ten designated "tribal homelands."

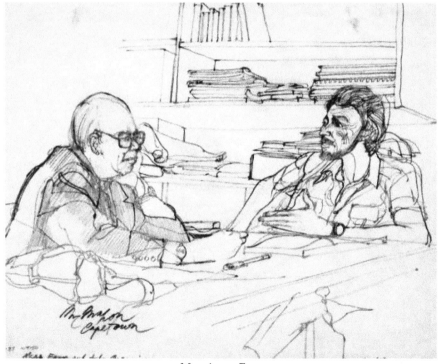

Monsignor Egan

Dad drew Monsignor Egan, "the city's [Chicago] conscience" when they traveled to Johannesburg with other activist priests to tell what they had learned from the United States Civil Rights Movement. Between 1987 and 1993, the South African National Party entered into bilateral negotiations with the African National Congress (ANC), the leading anti-apartheid political movement, for ending segregation and introducing majority rule. In 1990, prominent political prisoners like Nelson Mandela were released from prison. Apartheid legislation was repealed on June 17th, 1991.

Tapped on the shoulder by Tom Lenz, I rose from the pew to meet Ed Chambers, the community organizer, Saul Alinsky's heir, just before Monsignor Egan's funeral began. Ed asked me to sculpt Monsignor Egan twelve feet tall, like a Michael Collins portrait in Ireland. "I expect to see you at lunch after," he said, knowing his concept would come to be. At lunch, Ed Chambers and I envisioned the sculpture to convey a lively, action-oriented Jack Egan as a community organizer who happened to be a priest and consistently asks: "What are you doing for justice?"

Father Jack showed care in "being there" when I called for his advice and guidance for my exhibit *Just Plain Hardworking* for the Chicago History Museum and a WTTW documentary. When my mother passed away, I called Father Jack, who came her last night to bless her with last rites. I wanted to be there for Father Jack.

We titled the work "A Twentieth Century Priest," because Egan is a shining example of the work needed in support of social justice that dedicated clergy do every day. I placed great emphasis on Egan's hands, which are clasped in front of him and seem to be gesturing: "Come on, let's get going! 'What are you doing today for justice?' His ten-foot-high portrait on a circular limestone bench was unveiled at DePaul's Student Union in 2003. The same year the world found priests in the spotlight for the Church's cover-up of child abuse. It was a tough time to still be Catholic, a tough time to raise questioning Catholic children. What he taught me was to look into your conscience, look into yourself and what you have to offer, then don't be afraid to stand up and speak your mind.

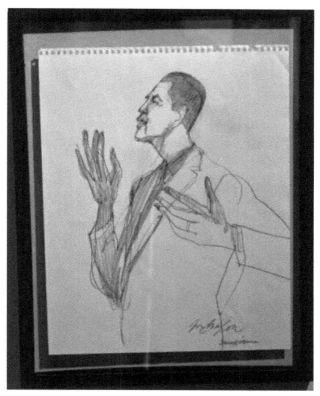

Illinois Senator Barack Obama
(2004)

Dad arrived at the Boston Back Bay Hilton for the Democratic National Convention in late July 2004. Illinois Senator Barack Obama had been selected to give the keynote speech. At the pre-events Senator Obama said hello and mentioned, "I need a nap." He was content that his speech would be a blip of national acclaim in history and forgotten by the end of the week. Dad witnessed and painted a humble Midwesterner who entered the east coast political scene and lost his normalcy after that keynote speech that reminded us of national unity with hope. Obama stood at the convention podium post-9/11 in a fractured and tense United States. Dad listened and painted the nonpartisan speeches on Monday and Tuesday. Michelle Obama asked for voters to choose a candidate to ensure a better future for children. Senator Barack Obama did not get his nap for another twelve years. He rose to the presidency with Abraham Lincoln's example of being honest, out of insider D.C. politics as if he just finished chopping firewood, and surrounded himself with a cabinet of rivals.

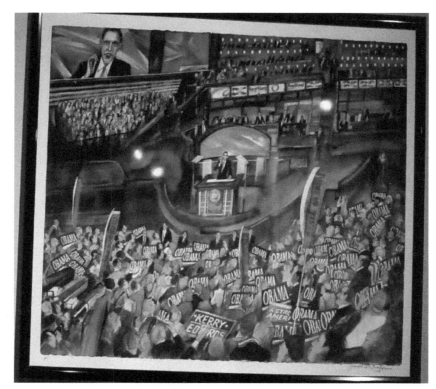

Illinois Senator Barack Obama gives the keynote speech at the 2004 Democratic Convention

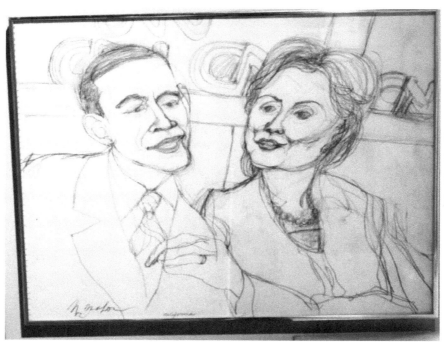

Senators Barack Obama and Hillary Clinton debate for the presidency

"Hawk and Dove" by Margot (cast marble)

2012—"Onward"

Dad passed away in January, 2012. At the memorial service, I read his eulogy. "On August 9, 1929, the Graf Zeppelin, nearly 800-feet-long and 110-feet-high, cast its shadow over eight-year-old Mac McMahon in Santa Monica, California. Earlier, after having been untethered from New Jersey, the Zeppelin headed to Manhattan where the record high Empire State Building was being built. It flew over Yankee Stadium, where Babe Ruth hit his 500th home run. It traversed past Wall Street that raced towards an all-time high. The Zeppelin then banked right and circumnavigated the globe over the recently defeated Nazi Party with its fringe politician Adolph Hitler and where Edith Frank was caring for her baby named Anne. Later, the Zeppelin was lifted, after a 4-million-person cheer of 'Bonzai!' from Japan by a typhoon before it soared along the coast of California. My father would have seen it. In his quiet way, he'd have understood the magnitude of this vision as a budding artist reporter. Mac shared this zeppelin story and his way of seeing the world with us throughout our childhood creating a context for the parents we shared. When he taught us the constellations, it was in reference to finding one's way home, if the radar system in his B-17 went down. On our Sunday kite flying ritual, he taught us about the

lift of the wind in relation to the angle of the string. When our balsa planes crashed, Mac had the right joke to turn our tears into a chuckle. Our Father soared above us, channeling this vision through his pencil tip into one bold, courageous, assured line, then another.

We are now awed when we see his list of accomplishments through 90 years, humbled by the man of a few words of pinpoint clarity. Each one of us is honored to have shared our lives with him. His balance of family, friends and work pivoted on his solitary mission with his artwork, like a spinning top. His drive came from deep within. His love was profound, both simple and complex. Mac likened himself to a stone on the beach that the waves washed over with varying magnitude. Though this year held a few tsunamis for him, the waves washed away again these past few weeks. I'll always remember his love-filled eyes expressing a spirit that will live "Onward!"

"Stop examining your belly button," Dad had said. "Get out there and make a change! If you have any inkling of injustice, make a difference." He had witnessed, painted and published his experiences in newspapers, magazines, on television, and in film. Dad was on location capturing the emotions of want and need, anger and frustration. With his art, he illumined awareness to nudge the world in a fairer direction, watched the change erase justice with presidential strokes of a pen and captured the protests again as people took to the streets with handmade signs to express their rights and wrongs. Our democracy is a chaotic, messy thing as we sway one way, then the other by vote or business, teaching, recreating or raising families. Our one common denominator is that we care about our children and their children. Our differences force us to see the opposing argument and our common fragile humanity.

Whether in the tot lot or board room, people need to come together to sustain life on earth with decisions made to protect all human life on earth with care for the oppressed. Let's embrace our differences and allow everyone to reach their potential. Take care of the earth that ceaselessly takes care of us. Learn from the plants, animals, and birds how to better flock with each other. When we herd, we are stronger to circle the weak and help the strong to break through the barriers. Set deep roots to weather the winds and soak up the storms so our leaves can reach to heaven while sheltering and feeding. Squawk when you see trouble, purr for the injured, snarl at injustice, and crow for any action in a sustainable direction. Come together to survive, talk it through and R•E•S•P•E•CT our mothers' children. If we have only one more moment in life, one last ounce of energy in our day, or one flash of brilliance, we can make a difference through action and art.

With thanks to Fred Shafer and Off Campus Writers Workshop, Heather Buchanan, Dan Burke, Julie Carpenter of the Oak Park Art League, Adrienne Kochman of the Ukrainian Institute of Art, Joe Berton, an artist and District 97 teacher, and Gloria Groom, Chair and David and Mary Winton Green Curator Painting and Sculpture of Europe, Brittany Nicole Adams of the Pritzker Legal Research Center, Marilyn Robb of Euclid Church, Katie Hale of the Lake Forest • Lake Bluff History Center, and Reverend Robert L. Powers from the Edmund Pettus protest.

For further reading:

1. "South Africa – Overcoming Apartheid". African Studies Center of Michigan State University. Retrieved 26 December 2013.

2. Rev. Robert McLughlin, Pastor of Holy Name Cathedral *Chicago Tribune* May 20, 2001.

3. Myre, Greg (18 June 1991). "South Africa ends racial classifications". Associated Press. Cape Girardeau: *Southeast Missourian*. Retrieved 1 March 2018.

4. Cape Girardeau: *Southeast Missourian*. Retrieved 1 March 2018.

RESIST! A History of Protest List of Franklin McMahon's Art

1. Auschwitz Gate
2. Emmett Till Trial in *Life* magazine 1955
3. Reverend Martin Luther King on West Madison Ave, Chicago 1968
4. Pope John XXIII, Vatican II 1958-1963
5. Catholic Forty-hour protest
6. Pope John Paul II, Vatican II Grant Park Mass Chicago 1979
7. Selma-Montgomery March Boy in tent city 1965
8. 8.Selma-Montgomery March Reenactment 1995
9. Father goes to work with child watching
10. Father and son watch television
11. Oak Park Housing Protest, Marion Mall 1966
12. Camden Street scene, New Jersey 1969-1971

13. Mickle Street, Camden New Jersey 1969-1971
14. Presidential candidate Shirley Chisholm 1972
15. Black Man Voting New Hampshire
16. Black Men/White Union
17. Trial Boy, Illinois 1983
18. El Salvador Protest Notre Dame 1985
19. Anti-War parade, Illinois Moslem neighborhood 2003
20. San Francisco war protest at Castro theatre with music
21. Iraq War Protest 2003
22. Evanston Bus War Protest 2003
23. LIAR Protest of George W. Bush, Wisconsin 2004
24. Senator Barack Obama's Democratic Convention Speech 2004
25. Senator Barack Obama 2004
26. Senators Hillary Clinton and Barack Obama Debate 2008

In June of 2018, the RESIST! Exhibition of Franklin McMahon 50 artworks was created to celebrate the 50th Anniversary of the Fair Housing Act, a change of the restrictive covenants that inspired Lorraine Hansberry to write *A Raisin in the Sun*.

RESIST! A Visual History of Protest

Franklin McMahon, Artist Reporter

May 11- June 1, 2018

Oak Park Art League 720 Chicago Avenue, Oak Park

October 2018 - February 2019

December 15 2022-February 12, 2023 Ukrainian Institute of Modern Art

RESIST! was exhibited at the Lake Forest • Lake Bluff History Center with a reading of *1968 Happened* by family members at a dinner setting during the exhibition. Part of the *RESIST!* was installed and is exhibited in the Oak Park History Museum in a Fair Housing Act exhibition. Northwestern University Pritzker Legal Research Center exhibited Franklin McMahon's Chicago Eight Conspiracy Trial artwork with the 50th Anniversary of the Conspiracy Trial. A kiosk showed many if the images collected by

the Chicago History Museum (CHM). In 2020, the Chicago History Museum created an online book with Franklin McMahon's Emmett Till Trial original drawing in notebooks and those published by *Life* magazine in 1955. And, CHM has an online 2020 exhibition of Franklin McMahon's collected Chicago Eight paintings. The Chicago Film Archives made each of Mac's films available online. Current feature length movies: *Apollo 11* includes Mac drawing; *Southside* featured length film has his ceramic Chicago scenes in Michelle Robinson's home and *The Trial of the Chicago 7* by Aaron Sorkin (Netflix) includes an actor representing Mac drawing the trial.

About the Author

Margot McMahon, daughter of Franklin McMahon, is an internationally-acclaimed artist and sculptor with work exhibited at the Smithsonian and around the world in public and private collections. Her work appears in the permanent collections of Yale University, the John D. and Catherine T. MacArthur Foundation, the John D. MacArthur State Park, The Museum of Contemporary Art in Chicago, The National Portrait Gallery, the Chicago History Museum, The Chicago Botanic Garden, and Soka Gakkai International. Over a period of five years, McMahon explored and interpreted her Irish Catholic heritage in the creation of art for St. Patrick's Church in Lake Forest, Illinois. Margot earned an MFA from Yale University and taught sculpture and drawing at the School of the Art Institute of Chicago, DePaul University and Yale University. She lives in Chicago with her husband. Their three grown children live on three coasts: Seattle, Chicago, and New York City.

Lightning Source UK Ltd.
Milton Keynes UK
UKHW052201111222
413756UK00008B/125